HOW TO VISIT AN ART MUSEUM

YA
701.1
IDE

Concept and text: Johan Idema
(www.johanidema.net)
Editing: Steffie Verstappen
Proofreading: Sarina Ruiter-Bouwhuis
Design: Vandejong, Judith van Werkhoven

BIS Publishers
Building Het Sieraad
Postjesweg 1
1057 DT Amsterdam
The Netherlands
T +31 (0)20 515 02 30
F +31 (0)20 515 02 39
bis@bispublishers.nl
www.bispublishers.nl

ISBN 978 90 6369 355 8
Second printing 2014

Johan Idema

HOW TO VISIT AN ART MUSEUM

Tips for a truly rewarding visit

S

B/S

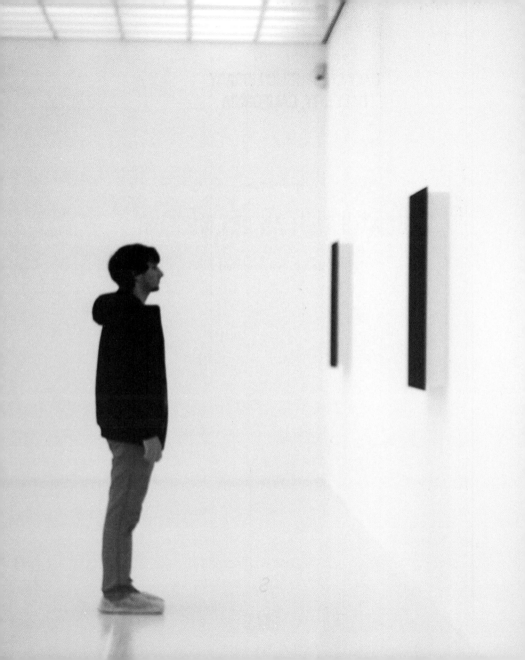

THE MOMENT WE STAND EYE
TO EYE WITH AN ARTWORK, WE
EXPECT SOMETHING TO HAPPEN.

ONCE INSIDE THE GALLERY, YOU ARE
ON YOUR OWN, AS THE MUSEUM
ASSUMES THAT THE ACT OF VIEWING
ART IS SELF-EXPLANATORY.

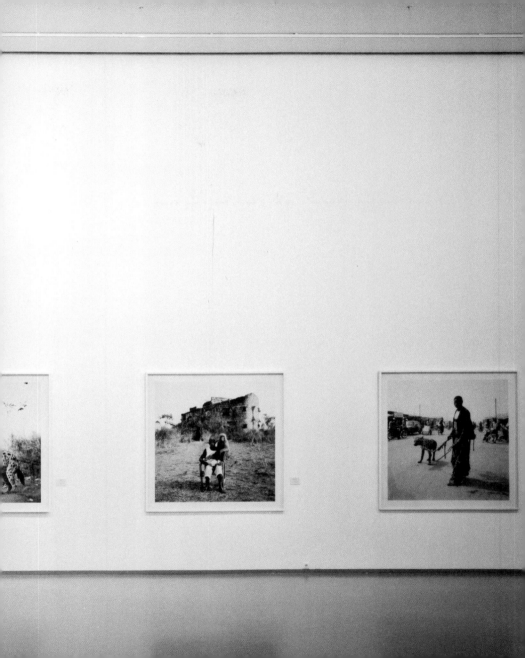

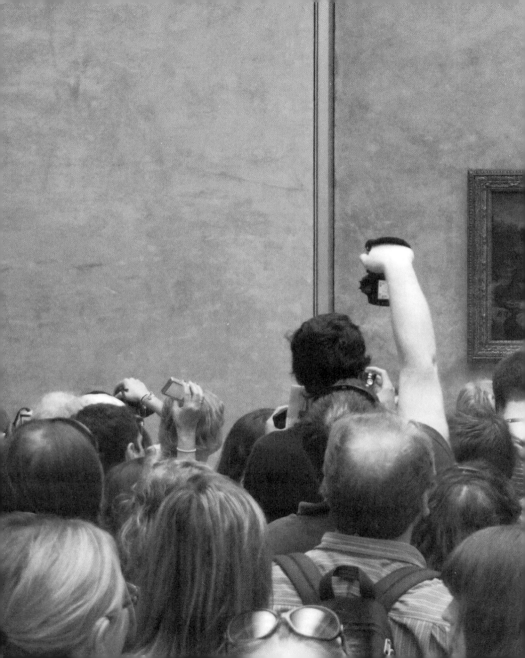

MASTERPIECE OR NOT,
WHAT ULTIMATELY COUNTS
IS WHETHER A WORK IS ABLE
TO GRAB YOUR ATTENTION.

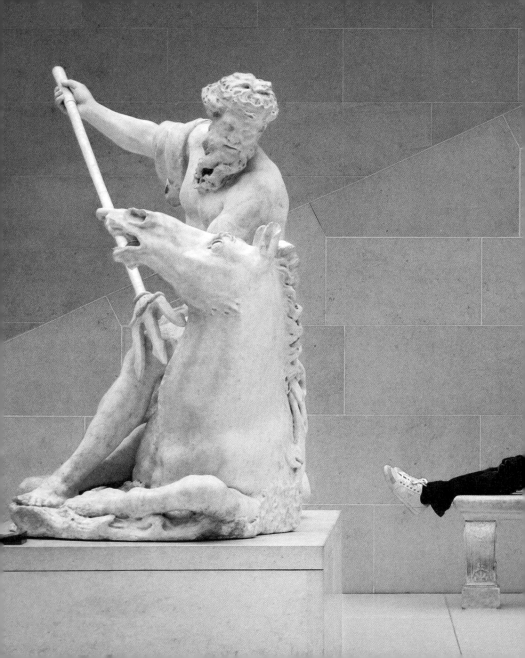

HOW COME STROLLING AROUND GALLERIES IS SO INEXPLICABLY TIRING FOR YOUR MUSCLES, NO MATTER HOW BRILLIANT THE EXHIBITS?

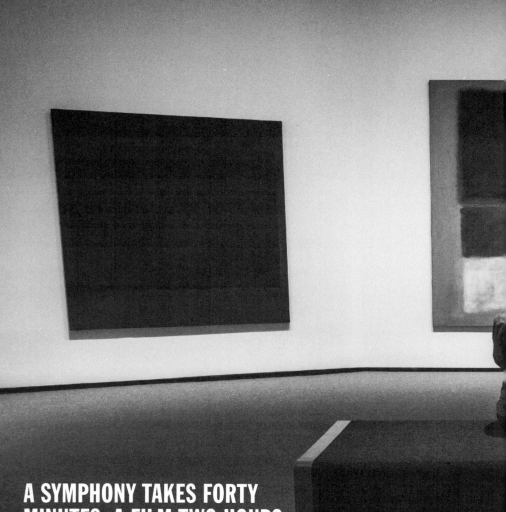

A SYMPHONY TAKES FORTY MINUTES, A FILM TWO HOURS, BUT MUSEUMS LET YOU DECIDE HOW MUCH TIME TO SPEND WITH AN ARTWORK.

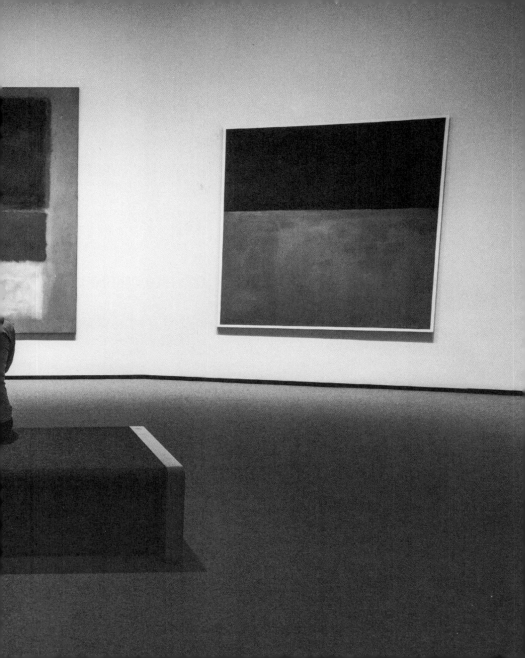

CONTENTS

CONTENTS

STOP WANDERING, START ACTING

If it wasn't for the white cube, this book wouldn't have been written. That's why it's important for you to know a thing or two about it.

When the white cube first appeared in the 1970s, it was meant to be a large, clean, neutral – and thus pure – white space. A place free of context. Inside the white cube, it would be just you and the artworks, nothing in between, alone together, in silence. But something went wrong: the white cube became an end in itself. The white cube gave museums and artists an excuse to focus on art for art's sake. As a result, the white cube's enclosement started to feel like isolation, its cleanliness like sterility, and art museums in general like laboratory-like spaces. More than merely being a space, the white cube came to represent a way of presenting art. And one that profoundly shapes your museum experience to this day.

Now, nearly fifty years later, you might think things have changed. Just look at all the wonderful art museums that have been built or renovated since, museum professionals will say. And they are right: some white cubes now have windows, while others boast spectacular architecture. What remains, however, is the etiquette museums follow to "serve" us their artworks. While art has reinvented itself in many ways throughout the past half-century – growing more diverse, complex and absurd than ever before – museums continue to display art in the same monotonous, minimalistic manner. This prompted famous art collector Charles Saatchi to describe the white cube as "antiseptic" and "worryingly old-fashioned and clichéd." And it's even getting worse, as the white cube now seems to be regarded as the only way to present art.

INTRODUCTION

Drifting from artwork to artwork

Too much purity harms the museum. Art needs to be connected to the real world in order to have meaning. "It's not that art should be seen only in rutty bombed-out environments," art critic Jerry Saltz justly remarks, "but there are other ways, both in space and behavior." Paradoxically, the serenity and strictness of most art museums hardly tolerate for them to explain or contextualize art. Clean walls and silence don't allow for a proper story, conversation, performance, party, or any other approach that helps you to understand and appreciate art. Nevertheless, this may just be the kind of guidance that many of us need in order to feel more comfortable at the museum.

Most art professionals and aficionados have full faith in the white cube. They believe it encourages the best way to behave around art. There is, however, a much larger group of museumgoers that feels differently. They enter the museum with the hope or even expectation that they will have a worthwhile experience. Once inside, we see them drifting from artwork to artwork, spending an average of ten or perhaps twenty seconds with each object. Their faces reveal interest, but also weariness. Observe them a little longer and you will notice that many of them seem lost, overwhelmed, bewildered, or even bored. "Our encounters with art do not always go as well as they might," philosopher Alain de Botton notes: "The way the establishment presents art to us doesn't invite us to bring ourselves into contact with works."

You can take charge

The museum functions as the prime location at which our ideas about art take shape. Why is it then that there are so many fabulous books on digesting art, but not a single one that informs you about how to use the museum in your best interest? Our encounters with art can be rewarding, even illuminating. But don't be fooled. It's a misconception that simply being in the museum, in the presence of great art and merely contemplating it means your art experience will be meaningful by definition. For that to happen, you'll have to forge a personal connection with the art, by somehow understanding it or by being touched by it. For many of us that spark doesn't ignite itself. While you would expect the museum to help you on your way, white cube protocol in fact often has the opposite effect: it prevents us from having a meaningful experience.

INTRODUCTION

The good news is that you can, to great degree, take charge and shape your museum experience yourself. Museums may have sound reasons to present art the way they do, but it's up to you how you want to experience it. Art museums may look and feel like a sterile white space, but that doesn't mean you should act accordingly. In order to make your visit worthwhile, you may actually be better off by following a different approach. That's what this book is about: it offers new perspectives on the way you can behave around art to turn your museum visit into a meaningful memory.

A little courage and creativity

Whether first-timer or frequent visitor, this book offers fresh perspectives on the art museum. It shows you the sense and nonsense of museum etiquette. It lets you tackle the challenges the white cube poses by taking things into your own hands a little more. Because the typical museum behavior – "Walk slowly, but keep walking", writer Gertrude Stein suggests – is seldom the most rewarding.

Find out how museum guards can be to your advantage. Learn the rule of thumb to distinguish good from bad art. Discover how kids offer you glimpses of the world hidden behind an artwork. Aiming for a satisfying stay requires you to sometimes leave the beaten track, taking care of things yourself or having a few sagacious insights at your disposal. This book shows you how with a little courage and creativity can you can find these new, engaging ways to connect with art and thus make your visit truly rewarding.

How to Visit an Art Museum is meant to be a pragmatic and imaginative handbook that caters to the curious and decisive museum visitor. Hopefully, it inspires you to make the art museum a more lively and – especially – more rewarding place. My wish is not so much for you to simply read this book but, rather, to start acting according to its insights. Because ultimately, the art museum is what you make it.

Johan Idema

HOW TO READ THIS BOOK

Making your museum visit worthwhile is not about doing one thing right. It's rather a matter of doing many things differently. Therefore, *How to Visit an Art Museum* is not written as a single, linear text for you to read from beginning to end. Instead, the book contains 32 suggestions – or visitation strategies, if you will – that will help to make your visit more meaningful.

Each suggestion aims to inspire or challenge you to evaluate your museum behavior to date and explore your options to act differently. Some of these tips address the interior of the museum, while others focus on how to look at art or how to relate to your co-visitors. For the sake of your reading pleasure, the different strategies are numbered, but aren't categorized. You are welcome to read them in any order you like.

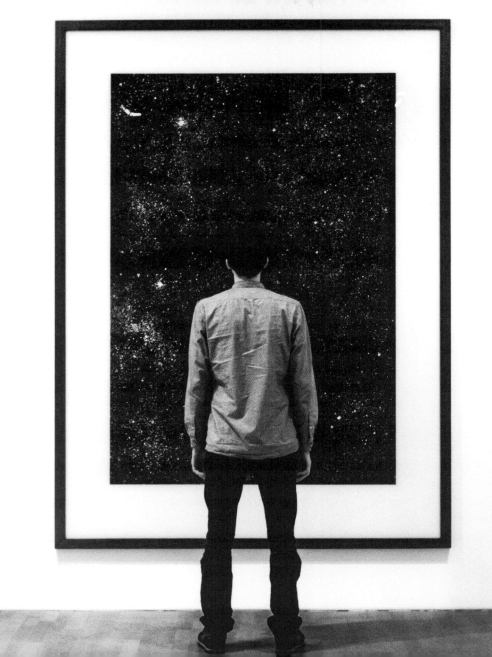

HOW TO VISIT

AN ART MUSEUM

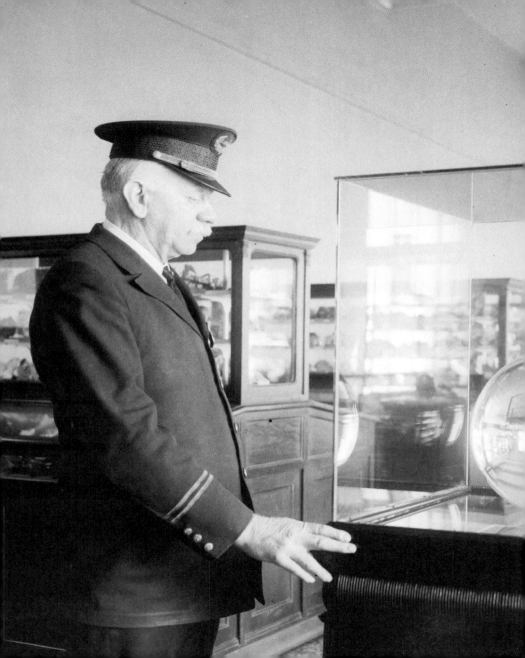

THE EYES OF THE MUSEUM

The irony of the museum guard is that he is the most visible and yet most overlooked staff member of the museum. Perhaps that's because we tend to consider guards, often silent and stone-faced, to be more machine-like than human. That's a grave misunderstanding. "Museum guards find the lost, shepherd the confused and save toddlers from collisions with immovable sculptures," as journalist David Wallis puts it. In order to put up with picture takers, soda smugglers and amateur art critics, guards require both the alertness of a police officer and the empathy of a kindergarten teacher.

Consider museum guards the ground troops of the art world, who deserve your utmost respect. Some of them actually have amazing knowledge of art – former guards include painters such as Jackson Pollock and Sol LeWitt. Others have impressive life stories to share, as they might well be refugee immigrants or former bodyguards. What makes guards particularly interesting is that they are the eyes of the museum. Day by day, they witness how we are fascinated, driven to tears or even bored by art – sights that provide them with many interesting insights.

As a resource of knowledge, inspiration or just plain fun, the value of museum guards is grossly understated. Many guards would speak with great passion, if only we asked them. Therein lies your opportunity. Have your questions ready and make your move when the gallery is quiet. Whatever the conversation, you will likely find that guards are able to offer what is often lacking in museums: human interaction and a proper conversation about art.

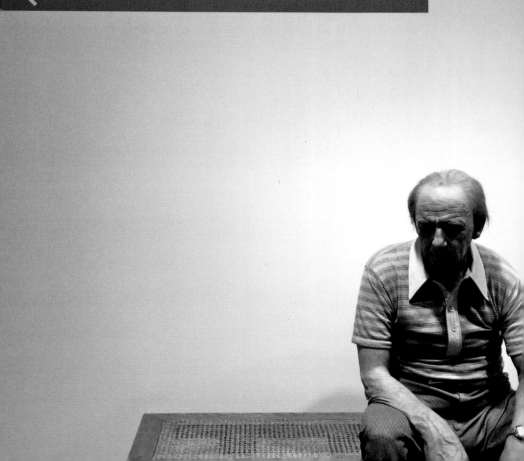

WALK SLOWLY, BUT KEEP WALKING

*mu·se·um legs noun \myu-zē-m-lāgs\ :
The aching legs one develops after a
prolonged period of slow walking in a
museum interspersed with standing still.
Similar to mall feet. <After three hours of
shuffling past Old Masters, my museum
legs are killing me>*

It doesn't matter how much of an athlete
you are. Or how thrilled you are by the
art on display. Museum legs can happen
to anyone. Ask people what is more tiring
physically, a walk in the countryside or
a visit to the museum, and many will
choose the latter.

How come strolling around galleries is so
inexplicably tiring for your muscles, no
matter how brilliant the exhibits? If you
think it's the many miles you're making,
guess again. In fact, it's the opposite that
causes your fatigue: you are sauntering.
Your legs have to keep you up without
the aid of speed.

When walking normally, you flex your legs
constantly and rhythmically. Looking at
art, however, involves a lot of stopping
and starting, contemplating, and irregular
walking. Standing, especially at pondering
angles, unevenly stresses your muscles
and joints.

The full explanation of why you feel ex-
hausted, however, is not purely physical.
The beauty, fun, emotion, shock and
surprise that art has to offer can exert
your eyes and brain as well. Especially
when overdosing on art, as you try to see
everything there is. Add to this the fact
that museums generally offer very little
seating, and there you have it: the perfect
cocktail for an achy pair of museum legs.

Did writer Gertrude Stein perhaps know
all of this when she wisely suggested:
"When in a museum, walk slowly, but
keep walking"? If you're determined to
avoid museum legs, just remember what
your mother used to tell you. Make sure
you're rested, don't try to take every-
thing in all at once, sit down now and
then, stay hydrated and don't forget to
eat. Art is a super-stimulus, but requires
a recovery period. Ultimately, museum
legs are about taking care of yourself
and taking time to recuperate.

PAINTINGS WITHOUT PEOPLE IN IT

Landscapes are paintings without people in it. Although this isn't entirely true, it does point out an essential challenge of landscape artists: how to convey a message with natural scenery being the only protagonist. →

You've probably found yourself looking at landscape art before. In fact, so many art museums have panoramas on view, you tend to forget – and museums do little to remind you – what landscapes have to offer you. You probably just enjoy the view, and then move on to the next vista. But a proper landscape scene can be rich in meaning and symbolism. "The real voyage of discovery consists not in seeking new landscapes, but in having new eyes," novelist Marcel Proust wrote. To that end, here are three guidelines that will allow you to dig deeper into landscapes.

1

If you think landscape artists aim to merely share with you a view they saw, think again. Landscape artists will never let the truth stand in the way of a good painting. Panoramas are almost always idealized – copied from reality with varying degrees of accuracy – or even entirely imaginary. It's all about what an artist wants you to see. And that's your fun challenge right there. Whether it's Caspar Friedrich's *The Great Preserve* or Claude Monet's *Poplars on the Epte*, if you look closely enough, you'll always discover something that gives away the fact that the artist is playing a game with your eyes.

2

Nature may be timeless, but the way landscapes are caught on canvas is always in line with prevailing views of the artist's era. At one point in history, landscape painters made sure to carefully place every tree, rock, or animal to comply with the rules of the established concept of beauty. Then landscapes became romantic, impressionist, and even modernist. Panoramas project the ideals of the time in which they were made. It's up to you to retrieve those ideals from the landscape.

3

Ultimately, a panorama is not about 'happy little trees', but mirrors the landscape of your own mind. Whether you respond with melancholy, pride or perhaps nostalgia – your longing to be there, wading in the water next to Claude Monet's *Bridge at Argenteuil* – the best landscapes can convey refined feelings. And those feelings, in turn, inspire ideas about life. So don't just enjoy the view, try to feel the sensation it sparks inside of you and think about what message the artist is in fact trying to convey. "Any landscape," said the philosopher Henri-Frédéric Amiel, "is a condition of the spirit."

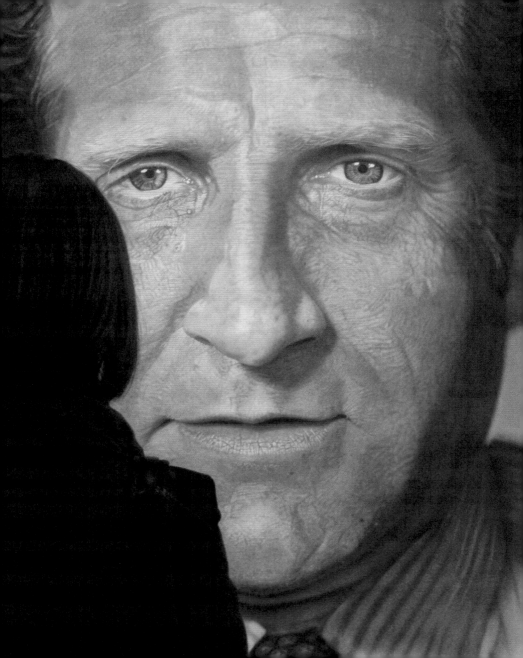

WHEN ART OCCURS

When a painting hangs in the gallery at night, with no one around to watch it, is it still a work of art? You'll probably answer "yes" to this question, arguing that the painting *is* the actual artwork, day or night. But there's another answer to this philosophical thought experiment. Modern philosophers believe that vision is a sensation excited in your eyes. If there are no eyes to see, there will be no vision. Art thus only occurs when being observed. Do you still follow?

Regardless of whether you believe an artwork is to represent either an object or a sensation, the moment we stand eye to eye with one, we expect something to happen. This is when we hope to be amazed, inspired and perhaps even challenged. To witness other visitors experiencing this moment can be captivating. The awe and disgust with which someone explores a provocative installation by the artist Paul McCarthy can be highly amusing. To see a young girl's face light up when she sees herself reflected in Jeff Koons' metallic "Balloon Dog" is priceless.

Museums are perfect for people watching. Watching people look at art can be just as exciting as taking in the art itself. Make it a routine component of your museum visit and you'll witness some beautiful, culturally choreographed dances of looks, pauses and reflections. For the best views, position yourself away from the works, but maintain a good view of people's faces. Watch with good intent, because there's a fine line between simple observation and staring at your co-visitors.

Standing in front of an artwork and observing it does not necessarily equal making sense of it. When you start paying attention to people's behavior in art museums, you'll notice quite some visitors wandering around, barely making contact with the works on display. Herein lies the true challenge of art museums: creating meaningful interaction between objects and people. Perhaps you'll now be more inclined to agree with modern philosophers after all: art isn't the object that hangs on the wall, but only happens in confrontation with its beholders.

THE BEAUTY AND THE AND BULLSHIT

When antique dealer Scott Wilson recovered an ugly painting from the trash, his friends suggested he start a museum. And so he did. →

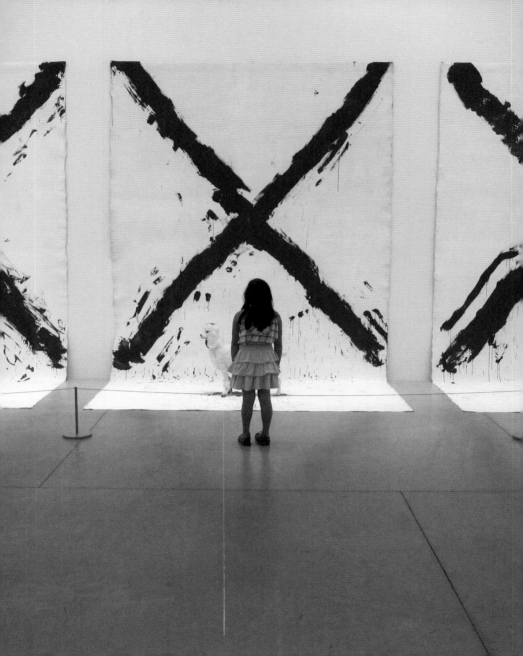

With exhibits of "art too bad to be ignored," Wilson's Museum of Bad Art focuses on work with serious intent but major flaws. Works on display range from talented artists that have gone awry to painters barely in control of the brush.

Looking at bad art can be surprisingly instructive. It may help you to understand the challenges related to creating a sound work of art. It also makes you aware that artists don't always succeed, even if their work may be put up in a legitimate museum. Once you realize this, you'll find out that as a museum visitor you have a challenge of your own: how do you distinguish the beauty from the bullshit? Does it require academic expertise to separate the good from the bad, or is it just a matter of taste?

Fortunately, artist Ed Ruscha provides us with a useful rule of thumb: "Good art," he suggests, "should elicit a response of 'Huh? Wow!', as opposed to 'Wow! Huh?', which indicates bad art." In other words, Art that initially dumbfounds and later amazes us is more rewarding in the long term than art that appeals primarily through shock or on the surface.

ART THAT INITIALLY DUMBFOUNDS AND LATER AMAZES US IS MORE REWARDING IN THE LONG TERM.

IF YOU DETEST A PAINTING AT FIRST SIGHT, THAT'S FINE. BUT KEEP LOOKING.

If you detest a painting at first sight, that's fine. But keep looking. You may think: What is this? Why is it so ugly? Who would want to make something like this? It's your primal 'Huh?' and a valid response. But keep looking, as you will have further responses and probably discover more. You may end up hating the painting even more fiercely, but with an enriched understanding of both the work and yourself. More often than not, however, your judgment will evolve into the opposite direction: what you think you don't like at first will intrigue, even please, you upon contemplation. As the work slowly transform from "Huh?" into "Wow!", you'll understand that good art takes time. Or, as the art critic Jerry Saltz puts it, "that bad art does exactly the opposite, ending up at 'Who cares?'"

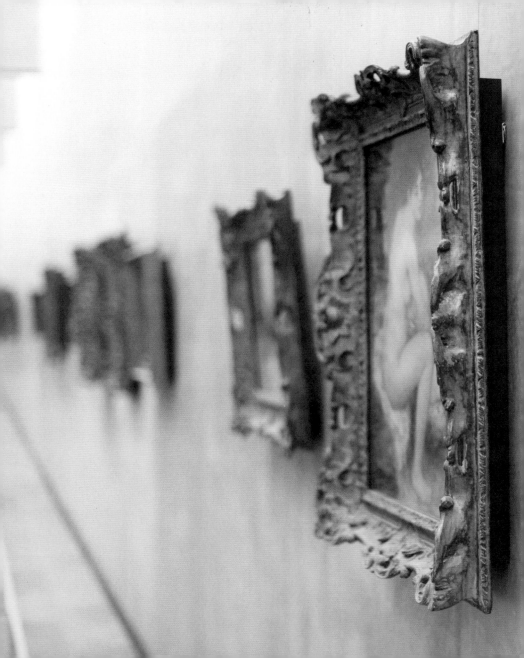

WHERE ART ENDS AND THE WORLD BEGINS

Think of your favorite painting, the one you could describe with your eyes closed. Now try to remember how it is framed. A riot of gold-leafed carvings? A simple strip of ebony? Nothing at all? A tenner to a penny says you haven't the faintest.
—Phil Daoust, journalist

An art museum once boldly organized an exhibition about frames. It included few paintings, but plenty of frames. If you think a frame is just a piece of wood that protects the painting, the exhibition might have persuaded you otherwise.

Frames serve purposes beyond the purely practical. Have you ever noticed how bad weather looks worse when seen through a window? That's exactly how frames influence your perception of the picture within. They intensify your visual experience. Or, as William Bailey, frame-expert and author of *Defining Edges*, puts it: "Frames are mediators between viewer and painting." Without them, you would at least miss many delicate color balances and subtleties of a painting. Most artists thus consider framing as part of the work. "A painting without a frame is like a soul without a body," Van Gogh once said.

What makes frames particularly intriguing is that they define where art ends and the rest of the world begins. This delicate decision fuels strong opinions. Some artists feel that, like the pedestal of a statue or the proscenium in a theater, a frame should enclose a painting in solitude. In this way, you experience it as an eminent, instantaneous presence. Others believe that frames should offer you a smooth transition from the physical world – being the gallery wall – into the imaginary realm of the painting.

Taking a step back, you might well consider the whole museum as a frame for your experience. As pure as the white cube might seem, it includes plenty of 'secret' spotlights, carefully chosen wall paints and plenty of other tricks to increase the visual impact of the work on display. Pay attention to this and you will add an interesting extra dimension to your museum visit: the theatrics of art museums. Since any painting comes to life only through illusion, you might as well ask yourself: where does one start and the other end?

SHOCK ME IF YOU CAN

It's Sunday morning. You just had a delicious brunch and feel great as you walk into the museum gallery. The first thing you encounter is a photo of a crucifix, submerged in the artist's own urine. Next, a black Virgin Mary, made from elephant dung, positioned in front of a collage of pornographic images. Suddenly, you feel a little less great. What's the matter?

Art that awes or disgusts you – think porn, bodily fluids, death or decay – may push you out of your comfort zone. And most museums do not exactly take you by the hand throughout the experience. Where to look when a painting offers you a picturesque yet undisguised view of a giant vagina? What to do when the smell in the gallery turns out to come from a glass box with a rotting cow's head? Walk away? Sure, you can. But if you think art should only be beautiful and uplifting, you're missing out.

How to adequately deal with shock art? Start off by getting in touch with your initial emotional reaction. Giggle, if you need to. Gasp, cry, get angry or shout. Who said art requires you to be silent and composed? Internalizing the shock is the essential first step towards understanding the work.

Once the primal "ugh" is out of the way, ask yourself why it was there in the first place. What is it that makes you uncomfortable? Try to accept your emotions for what they are and consider the work as you would any other one. Look for clues, read the labels. Does the artist provoke in order to make a statement? Does he want to confront you with your feelings? Once you move past the initial shock, you will often find a worthwhile thought or message – one that may need some controversy to be told effectively.

Many artists feel that generating shock is the duty of those who aim to project the real world back at itself. "Conditions in society are shocking, and art really does become a mirror to society in that way," one artist puts it. Museums are one of the few public places where we can, freely and rather innocently, experience shock. This can be incredibly illuminating. Let's cherish this freedom by now and then voluntarily taking a hit. It will eventually make you stronger.

BUT, IS IT ART?

There's always someone who will ask that eternal question: "But, is it art?" →

Because of art's infinite appearances – from paintings to performances, from ready-made objects to spaces, from overwhelmingly beautiful to dead ugly – it's often a relevant question. How you answer it is even more important. Ramshackle views on art often result in unrealistic expectations that, in turn, culminate in disappointing museum visits.

Putting into words something that is supposed to be indescribable may feel counterintuitive to many. Those who say art defies definition, however, are keeping things unnecessarily fuzzy. Defining art, in the best possible manner we can, is crucial to making it accessible. This doesn't mean there's one right way to define art. Art is open to a multitude of interpretations.

Many people believe that a piece should be beautiful or inspiring in order to qualify as art. When they encounter something aberrant, and museums don't take them by the hand to comprehend it, they turn off. "Is this it?" they ask, while looking at a metallic box by Donald Judd. Or "My son could do this," when in front of a Karel Appel or Jackson Pollock. Apparently, definitions serve like comfort zones, too. When art is too blurred to fit one's taste, it creates a ton of uneasiness.

THOSE WHO SAY ART DEFIES DEFINITION ARE KEEPING THINGS UNNECESSARILY FUZZY.

ALL YOU NEED TO START ENJOYING ART IS A LITTLE CONTEXT AND THE RIGHT MINDSET.

Some consider art an acquired taste. Like wine or cheese, it's supposed to take an education to appreciate it. But all you need to start enjoying art is a little context and the right mindset. What ways, then, to define art are useful in the museum? Try to become aware of what art is capable of. Go beyond the object and, with a world of possibilities in the back of your mind, find out what an artist is trying to achieve. According to artist Zineb Sedira "art can make you escape, make political and personal statements, think, raise awareness, question the world, tell stories, record memories and keep them alive, challenge ideas and the world. See the world poetically. See the world as you wish." It is these thoughts – or definitions, if you will – that you should cherish. They are the perfect aid to helping you manage your expectations. Remember them when you go to the museum next time and you'll be well on your way to making your visit a rewarding one.

FRIENDS YOU HAVEN'T YET MET

"The ultimate model for an experience of art," museum expert Amy Whitaker argues, "is a good dinner table conversation." And she's right. What a sensuous experience it would be to enjoy, for instance, a flamboyant Matisse painting with a tasty soufflé, great guests and a ruby red Zinfandel.

Food in the gallery is like rock music in church: a definite no-no. But what Whitaker really pleads for – great conversations about art – is possible. Still, museums are not exactly lively salons where we eagerly interact with each other about art. Instead, galleries generally bathe in silence. If we must speak, we do so modestly. It's even possible to visit a museum, be among hundreds of like-minded art lovers, and yet not speak to a single person.

The barriers that prevent us from talking to strangers may be high, but the potential rewards of doing so anyway are higher. Especially during our museum visit. What may start off as small talk may end in a conversation about life. What's particularly interesting about our casual dialogues about art is that we are then

less likely to feel the need to be right. This allows us to share our thoughts, criticisms, and enthusiasm more easily, without very much judgment, thereby deepening our art experience.

That's why you should take on every opportunity you have to exchange thoughts with other visitors. Or better yet, create them, even if talking to strangers is not your thing. You might be surprised that, more than elsewhere, the museum turns out to be a place where people are open to conversation. Start off carefully by posing a simple question. Soon, you'll find that someone else's knowledge, or humor, may offer you new and surprising ways to understand a work of art.

Some people don't feel like talking in museums. That's fine. A museum can also serve as a wonderful place to find peace and stillness. But the museum in its entirety as a quiet zone? Come on, leave your shell and connect with fellow art lovers. Try it twice or three times, and you'll agree with poet William Butler Yeats that: "There are no strangers here, only friends you haven't yet met."

CHEWING GUM STICKING ON THE INSIDE OF YOUR BRAIN

Masterpieces are a museum's crown jewels. Whether it's the Mona Lisa with her seductive smile or the rich color fields of Rothko, we embrace them as supreme achievements, based on their reputation. But who actually designates masterpieces? Recently, art production has become so prolific that the number of masterpieces has grown exponentially. In fact, 'masterpiece' has come be the most overused word in the art world.

When curators at the Paris Louvre were preparing an exhibition called "The Louvre and the Masterpiece", they agreed on a series of criteria that an artwork should meet in order to be qualified as a masterpiece. The series included superlative craftsmanship, extraordinary design, great antiquity, rich materials, purity of form, artistic genius, originality, and the work's influence on other artists. It turned out to be merely a matter of time before the use of those criteria spiraled out of control and lead to a big discussion. "It became evident that it is extremely difficult, if not impossible, to articulate a definition of masterpiece that could be accepted universally," the curators concluded.

Perhaps the only satisfactory definition of 'masterpiece' comes from novelist Joyce Cary. He wrote that "nothing is a masterpiece until it's about two hundred years old. A picture is like a tree or a church, you've got to let it grow into a masterpiece."

You could also consider 'masterpiecing' the museum world's ball game. Its players – curators, critics, dealers, and collectors – are highly competitive, because money, influence and public attention are at stake. Getting an exceptional work recognized as a true work of genius equals winning. The museum gallery represents the 'Hall of Fame' where you can take in the outcome.

Masterpiece or not, what ultimately counts is whether a work is able to grab your attention. "You know when you've encountered a masterpiece, because it stays with you the rest of your life," according to artist Anne Richter. "It's like chewing gum sticking on the inside of your brain." So trust your instincts. Once you find your masterpiece, you only have one thing left to do: forget about the label and enjoy the art.

THE PERFECT ANTI-DOTES

It may come as a surprise, but the best museum guide in the world lives at your house. It is, in fact, your very own kid. →

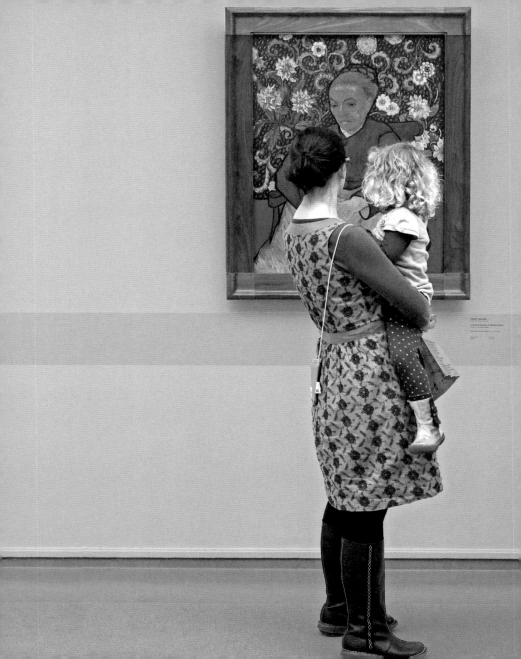

KIDS ARE EXPERTS AT POSING QUESTIONS AND SEEING THINGS DIFFERENTLY — BOTH CRUCIAL SKILLS FOR ART CRITICS.

You probably already know that he or she is a productive artist, covering your refrigerator door with a Picasso-like oeuvre. But children are excellent art critics, too. Your boy or girl has a special talent for offering you a glimpse of the hidden world behind an artwork.

What makes kids so good at art? They are experts at posing questions and seeing things differently — both crucial skills for art critics. The art of questioning comes naturally to children. They ask the questions that adults do not dare to ask and they can't be fooled with simplistic answers. Their original minds come up with solutions that we, grown-ups, consider to be creative, inventive, and authentic. In fact, museums should offer a rent-a-kid service, allowing everyone to pick up a miniature museum guide at the entrance.

If you want to take full advantage of your own young art guide's perspective, be sure to include some of the more absurd and challenging artworks. Up until the age of four, children have no problem with abstraction. It makes them mini-masters at Picasso, Pollock, and the like. Let them enlighten you with what they think these artists have actually painted. Kids are also experts in conceptual art, as they can vigorously explore a thought or idea. Never pass up the opportunity to let your child explain to you a Soll LeWitt or Marcel Duchamp. Take in their observations, and do not hesitate to pose tough questions about the works that puzzle you. Kids might very well offer you new insights and perspectives.

Children are the perfect antidotes to the act-like-you-know attitude that tends to accompany art museums. Their sincerity and boldness can loosen up even the stiffest arts patron. They aren't held back by a perceived lack of knowledge or expertise – like we often are. Instead, kids feel free to react to and comment on all they see. Over the years, you might have lost the curiosity and open mind they still have, and which are indispensable to understanding and appreciating art. Therefore, the best lesson your son or daughter can offer you when visiting the museum is to reconnect to your inner child. If you, too, manage to keep your mind young, you will discover the best that art has to offer.

NEVER PASS UP THE OPPORTUNITY TO LET YOUR CHILD EXPLAIN TO YOU A SOLL LEWITT OR MARCEL DUCHAMP.

Frank Stella

American, born 1936

The Marriage of Reason and Squalor, II 1959
Enamel on canvas

Larry Aldrich Foundation Fund, 1959

This painting consists of two identical vertical sets
of concentric, inverted U shapes. Each half contains
twelve stripes of black enamel paint that seem to
radiate from the single vertical unpainted line at
their center. Out of this "regulated pattern," Stella
explained, he "forces illusionistic space out of the
painting at a constant rate." Working freehand he
applied the commercial black enamel paint with a
housepainter's brush; slight irregularities are visible.
Preferring not to interpret this work's descriptive
title, the artist said of *The Marriage of Reason and
Squalor, II,* "What you see is what you see."

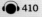 410

REALITY FUNCTIONS AS MY FIELD OF ACTION

Making your way through the museum, you will encounter pompous, overblown prose that is generally referred to as *artspeak*. You will find it in exhibition texts and on wall labels. It includes phrases such as: "The artist confronts us with our own preconceived hierarchy of cultural values and assumptions of artistic worth."

Artspeak has an odd parallel to pornography: you'll know it when you see it. It reads like inexpertly translated French and contains a wealth of contradictions and ambiguities. *Artspeak* tends to use more rather than fewer words and displays an odd brand of linguistic nonchalance, as ordinary words take on non-specific alien functions. "Reality," an artist writes, "functions as my field of action."

Artspeak pleases art aficionados who frequent museums, but for many of us it evokes feelings of bafflement or irritation. This makes *artspeak* the biggest drawback to museums. In describing art in opaque, pretentious and often unintelligible ways, museums drive a wedge between themselves and their audience.

You may thus wonder what it is that allows *artspeak* to survive. The short answer is that museum curators don't tend to invest in their writing skills. The more elaborate one is that a mix of etiquette and routine makes curators actually prefer *artspeak*.

Ultimately, you will have to endure *artspeak* to get on. Knowing how to recognize *artspeak*'s empty phrases helps you to achieve this. Be alert when museums tell you that a work "questions," "subverts" or "touches upon" the subjects of "alienation" or "globalization" (or any other combination of broad, generic themes). Ignoring these clichés will keep you safe from being puzzled and annoyed time and again.

Effective explanation is concise, specific and focuses on what you can get from art. Sometimes you'll stumble upon phrases in *artspeak* that do make you understand or connect with an artwork. These words may stay with you forever. Such gems make up the beauty in the bullshit.

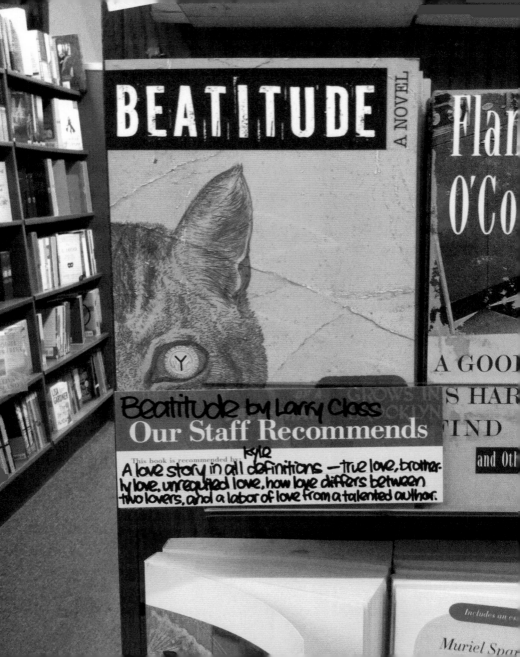

BEATITUDE

A NOVEL

Beatitude by Larry Closs

Our Staff Recommends

This book is recommended by Kyle

A love story in all definitions — true love, brotherly love, unrequited love, how love differs between two lovers, and a labor of love from a talented author.

THE SOUL OF A MUSEUM

What's the difference between an art museum and a bookstore? Pictures versus words? Sure. Seeing versus buying? That too. There is, however, a less obvious but perhaps even more relevant difference, called *staff picks*. Bookstores have them, museums don't. Staff picks are handwritten cards, attached to the books that staff members are particularly excited about. In their own writing they explain to you why you should "read this book." If you're someone who is easily overwhelmed by the overkill of art in museums, staff picks could offer you an easy way to navigate your way through.

Staff picks are mini-endorsements, full of passion, humor and insights. They make the bookstore a little more personal. It feels like the staff actually read the book *for you*. Museums could use some of that personal attention. They have plenty of opinionated individuals on their payroll who would be able to promote their personal favorites – no doubt including entertaining and inspiring stories.

Great idea, you will say, but museums don't have staff favorites. You're right. That's where you step into the picture. You will have to generate your own staff picks. How? Simply by asking. The lady at the box office, the guard in the gallery, or the waiter in the restaurant: they are all in a perfect position to recommend their favorites to you. They know what's on display and they often – as many are artists themselves – know exactly what they like. Ask them what they think you should see and why, and you'll be surprised and delighted. And they might be, too. If you ask kindly, they might even go with you, personally presenting their favorite to you, likely including one or two anecdotes.

Personal recommendations make your museum visit more human and informal. Perhaps museum staff picks won't increase your understanding of a given painting in an art-historical sense, but that's what wall labels are for. What you *will* learn is what a work of art may mean to someone else and the personal stories that may hide behind it. For many visitors this is infinitely more valuable than any analytical explanation. Because ultimately, staff recommendations offer you a glimpse of something that many of us are looking for: the true soul of a museum.

THE UN-DISGUISED VIEW OF THE HUMAN BODY

Ms. McGee is an art teacher with over twenty-five years of teaching experience and is now out of a job. →

IT'S THE PROXIMITY AND SHARED EXPERIENCE THAT TURN NUDITY INTO AN ISSUE.

When she took her fifth-grade class on a field trip to the local art museum, one of her students encountered nude art. The child's parents filed a complaint with the school board, which led to Ms. McGee's lay-off.

Although it may seem to be an incident, what happened to Ms. McGee touches on a much larger issue: how to deal with nudity in the museum. If there's anyone we should hold accountable for the frequent appearance of nudity in the museum, it's the ancient Greeks. They believed that covering the body with clothes only concealed its natural beauty. Since then, the human body, disrobed and displayed in all its glory, has become one of the most enduring motifs in Western art.

You are probably perfectly aware of the central position of 'the nude' in art history. And you likely have, within the limits of good taste, no problem with it. But doesn't it somehow feel differently when you're at the museum?

Being up close with a nude, admiring it or perhaps awkwardly discussing it together with friends or – worse – visiting relatives is what makes the difference. It's the proximity and shared experience that turn nudity into an issue. And there's more: in art, nudity is hardly ever just nudity. Nudes are either larger than life, feature grotesque forms or demonstrate bizarre, confronting poses. And that's when things become truly uncomfortable. Looking at Gustave Courbet's realistic and life-size oil painting of a woman's nude pelvis together with your grandfather probably doesn't line up with your idea of a rewarding museum visit.

Trying to avoid unclothed figures in art museums is near to impossible. How to deal with nudity then?

A prestigious museum once organized an exhibition featuring an overview of artworks of the nude male form. For a special after-hours event, visitors were invited to tour the museum *au naturel*. The idea was that with no barrier between you and the art, the works would be appreciated even more. With only naked visitors in the gallery, nude quickly became the new normal for those around.

And that's exactly the point. To avoid the uneasiness that may stand in the way of us enjoying the art, we want nudity in the museum to be neutral or just esthetically pleasing. But to intelligently appreciate nudity in art, we should in fact be open to any emotions it induces. Seeing a sculpture of a nude body may very well spark feelings of awkwardness, eroticism, humor, anger, or even perversity, depending on the work. Don't try to avoid the mixed reaction that nudity may inspire in you. Instead, accept it and, perhaps, even take pleasure in it. Art is connected to life, and can excite the whole *palette* of sensations that you'll also find in the real world. In the museum, feeling uncomfortable is often a good sign. It tells you that you have arrived at the edge of your comfort zone. Which so happens to be the place where the exciting things in life happen.

IN THE MUSEUM, FEELING UNCOMFORTABLE IS OFTEN A GOOD SIGN.

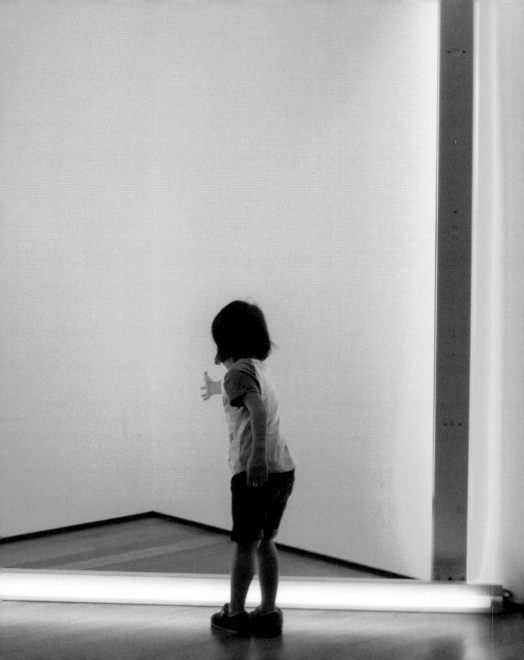

HE FELT SMOOTH AND FIRM

His legs were strong and lean. She felt his muscular calves and touched his thighs, his tense quadriceps contracted mid-stride. His right hand was up in the air, but she'd grabbed his other fist down by his waist, caressing the knuckles pointed at the floor. She felt surprise, excitement even, standing before this giant man. He felt smooth and firm – and ice-cold, too.
—Daphnée Denis on Rodin's six-foot sculpture of Saint John the Baptist, as felt by a blind woman

Touching art used to be routine in earlier centuries. It was considered essential to fully appreciating the beauty of art. Today, art museums have almost entirely banned the tactile experience. Art is meant for the eyes only. But is it really? Of course, most art is too delicate for our shaky and moist hands. Touching two-dimensional works doesn't make much sense either. But beyond these obvious constraints, there is still a world to explore.

"Everything that has form is only known through the sense of touch," according to philosopher Gottfried Herder. So if you get the chance to touch an artwork, seize it with both hands. Placing your hands right where the artist's hands once were can be exciting. It will allow you to literally feel the material and get a sense for the artist's craftsmanship on a whole new level.

How to get that hands-on experience in a hands-off museum world? Start by simply asking. Some museums offer art that can, or is even meant to, be touched. Museums that truly acknowledge your urge to feel, offer tactile tours (white gloves included!). Educators will guide your hands, ask you what you feel and help you to create meaningful connections with the (usually) sculptures through touch.

Several museums organize tours for blind visitors. Try to join one, as non-blinds are often allowed. Sensing art together with people who are used to seeing through their hands is an amazing experience. Listening to them as they describe their observations can be tremendously insightful and inspiring. In fact, when it comes to art, the visually impaired could help the sighted community to feel what can't be touched. Which museum will be first to offer tours with blind guides?

UNTITLED #3, 1973

"If I could say it in words, there would be no reason to paint," artist Edward Hopper pinpoints his conviction that art should identify its subject and message without the use of titles. Many artists agree with Hopper: they aim to avoid what to them feels like imposing text upon an image.

Although this sounds plausible, you will discover another truth when standing in front of a piece of art: you will need an entry point into the work. Not least when you're looking at something that is abstract to such an extent that it has become un-recognizable. Therefore, there are just as many artists who do feel they need to speak for their work. "Would you send a child into the world without a name?" as one of them remarks.

Titles satiate your urge to make sense of art. They offer you a key to unlock (some of) the meaning of an artwork. The best titles even hit you in the gut, have a sense of poetry and expand the idea of a piece. The title of Damien Hirst's *Mother and Child, Divided* adds strong meaning to the work. *Dissected Cow and Calf* wouldn't have exerted the same power, for obvious reasons.

If an artist chooses not to title his work, because he doesn't want to influence your experience of it, he obviously can. The best you can do is try to understand his motives. Even off-putting titles may make sense later. *Design in Blue and Green* or *Pattern No. 2 – Squares* may not seem to offer you much of a clue initially. But maybe the artist wants you to realize that his art focuses on form, color, texture and other formal qualities only. He kindly advises you to stop at the surface and not look for deeper meaning.

Art that is both abstract and nameless puts many people off. Perhaps you are one of them. Sure, you can visit a museum and only look at works that have been assigned descriptive titles, but you would certainly miss out on many amazing artworks. Great art doesn't necessarily have to have a name. Annoying as it may seem at first, you'll just have to get over it. Period.

NO PHOTOS !

You are standing in front of a famous Marlene Dumas painting: a grotesque, deformed image of a human face. You take out your smartphone. →

You position your friend, who is in the process of adopting a similar facial expression, next to the work. As you frame the shot, a guard steps forward, raising his voice: "No photos!" The gallery startles. Somewhat upset and embarrassed, you apologize and leave the room.

Has this ever happened to you? It occurs many times a day in art museums worldwide. Most have restrictive photo policies. Quite ironically so, when you realize that numerous artists, including Andy Warhol and Gerhard Richter, make no issue of modeling their work after the photographs of others.

You may question most of the arguments that museums cite for enforcing photographing restrictions. Does taking pictures really distract other visitors? Who's to say that it cannibalizes postcard sales? There is, however, one legitimate reason: copyright. Museums must respect their intellectual property agreements with donors and lenders. Fortunately, this seldom concerns the majority of art on display.

TAKING PICTURES IS A WAY OF CONNECTING TO AND PARTICIPATING IN THE ART.

DON'T CAPTURE THE ARTWORK ITSELF, BUT YOUR EXPERIENCE OF IT.

Purists will argue that art museums have become tourist destinations: the art primarily serves as a photo opportunity. But arguably, taking pictures is also a way of connecting to and participating in the art, as it unleashes our excitement and involvement. Taking a clever picture can lead to more meaningful interaction with art. It may be wise for museums to encourage this. Why not offer paintings or sculptures that are especially created to be photographed? Why not organize a contest for the best artwork photography?

How, then, to take an original and intelligent photo of an artwork? Challenge yourself, not by attempting to capture the artwork itself, but your experience of it. Why not try to include something of yourself or your co-visitors? Portrait the back silhouette of your girlfriend, pondering in front of her favorite painting. Catch a striking similarity between your son's face and a Picasso portrait. Stage a fictional conversation between a Ron Mueck sculpture and your friend. Artists came up with the art, now you get creative with taking its picture.

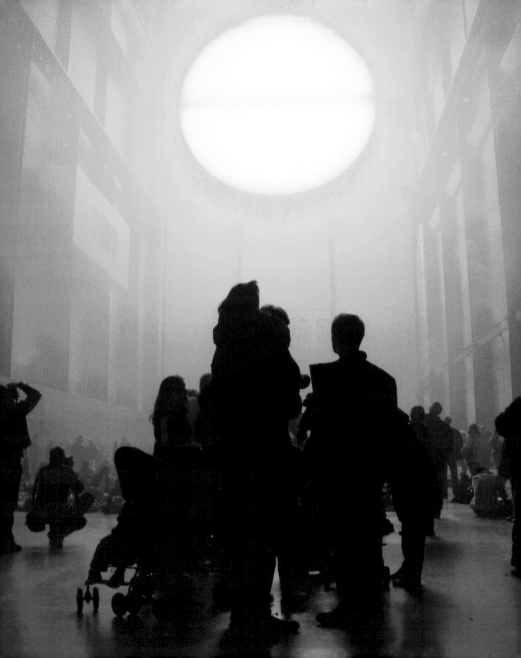

NOT JUST A GRAVEYARD FOR ART

Everybody has their own understanding of what an art museum represents. A visitor may think of it as a building that houses famous works of art. A curator will define it as a non-profit institution, acquiring, conserving, researching and exhibiting art. Ask a pessimist and he might describe an art museum as a graveyard for art.

How you perceive things determines how you behave towards them. Research tells us that your ideas about an art museum strongly influence what you get out of your visit. You may not always be aware of your specific frame of mind, but you should. Because to most people an art museum is no more than a collection of objects in a distinctive work of architecture. And that's quite a limited, materialistic view.

An art museum can be a great place to meet a friend and have a meaningful conversation about life, induced by what's on display. An art museum can be the site where you celebrate your birthday or where you go after a funeral to process your grief. You can visit an art museum to just enjoy the peace or to get rid of your stress. And, who knows? You might even run into your future spouse at the museum.

The more elaborate your notion of what an art museum could offer you, the better you'll recognize your chances to make it happen. "Success is where preparation and opportunity meet," automobile racer Bobby Unser once remarked. Expand or reconsider what you think an art museum represents, and your next visit will be more rewarding. That's a promise.

SELFIES AVANT LA LETTRE

Selfies avant la lettre, is that what portraits are? For centuries, portraits were used intensively for recognition and remembrance. →

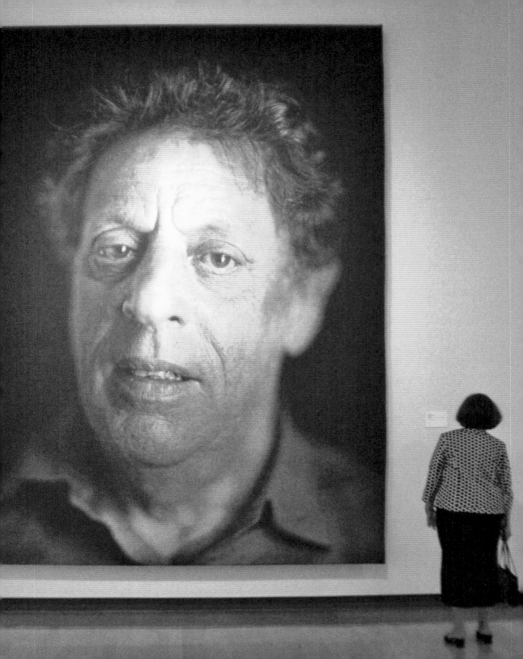

Sixteenth-century painter Hans Holbein traveled thousands of miles to portray potential wedding candidates for his royal clients. Frida Kahlo left friends her self-portrait in her absence, "so that you will have my presence all the days and nights that I am away from you."

Portraiture represents a rich and significant genre in the visual arts. You will encounter portraits in almost every art museum. They offer you the chance to shamelessly stare at someone's face – an opportunity you seldom get in real life. Portraitists are great diplomats, too. They are able to influence the moods and expectations of their sitters, especially when they display great vanity or plain ugliness. They know that, caught with the correct expression and observed in the right light, the human face will always be beautiful.

But if you believe that portraiture is all about depicting literal likeness, you're missing the point. There's much more to it. The following three guidelines will allow you to deepen your portrait experience.

1

The face is the soul of the body. That's why well-executed portraits are essentially about the inner significance of their subjects. A great portrait painter will show you the character and essential emotions of his sitter. Look for it, while paying special attention to the eyes. According to portraitist Gordon Aymar, "the eyebrows can register, almost single-handedly, wonder, pity, fright, pain, cynicism, concentration, wistfulness, displeasure, and expectation, in infinite variations and combinations."

2

Portraiture is a respectable genre that many painters try at least once. Not so much to achieve a veracious rendering of a person's image, but to test and nurture their own style. Because, as Oscar Wilde wisely observed: "Every portrait that is painted with feeling is a portrait of the artist, not of the sitter." Look at portraits with this perspective in mind and you may start noticing a whole new layer of meaningful detail.

3

Portraiture transcends the personal. It can tell you as much about life as any other genre of painting. Once you come across a truly terrific portrait, you'll notice how it makes you forget the face but remember the drama, doubts, hopes and dreams that you experience in your own life. Make it your mission to find the portrait that does that marvelous trick for you. It beats therapy.

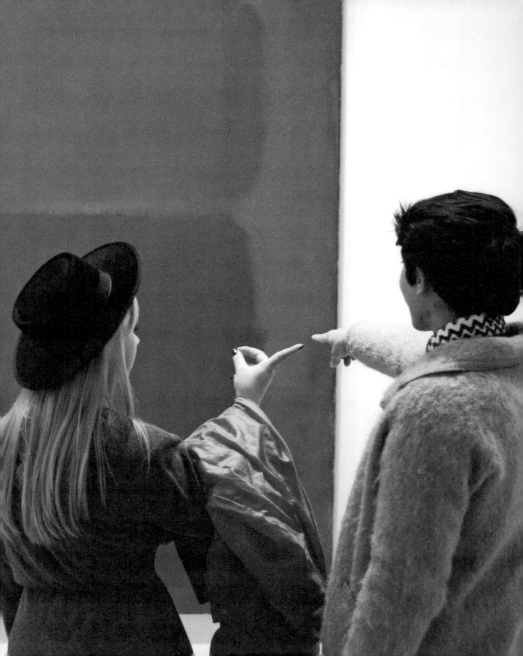

ASK ME ABOUT THE ART

Although they look just like your average visitor, casually hanging around in the museum, they are no such thing. Instead, they have an extensive background in the arts and usually wear a button that reads "Ask Me about the Art." If you approach them, they will spend time with you, taking in the beauty of an ancient Vermeer or the dizzying energy of a Jackson Pollock painting.

Meet the gallery guides. They're a rarity, but a brilliant idea. Gallery guides offer you the singular opportunity to explore art through one-on-one conversation. They know how to invite you, unsolicited yet non-invasively, to look closer and dig deeper. "Our job is to get people to slow down," as one gallery guide puts it, "we help you to think on your toes."

Frank Zappa argued that talking about art is like dancing about architecture: a really stupid thing to do. Gallery guides prove him wrong. They'll show you that you *can* discuss a painting and that the best place to do so is, in fact, directly in front of it.

There's one essential behavior that gallery guides will not display: they will never act as an authoritative voice. When it comes to art, many of us are still afraid to come across as ignorant about something that is considered a fundamental component of civilization—and being civilized. That's why gallery guides aim to make us feel comfortable and encourage us to construct our own meanings.

"I still think of the time I spent listening to and speaking with the gallery guide," one visitor to the Guggenheim Museum recalls. "Guided tours are always lecture style. But this was different and interesting." It's the element of surprise and the unique qualities of one-on-one conversation that makes gallery guides special. What's more, you actively shape your encounter with them yourself, which turns the experience into a lasting memory.

Fortunately, a growing number of museums are introducing gallery guides. In fact, every museum should have them on staff. Once they do, you will no longer be needing this book.

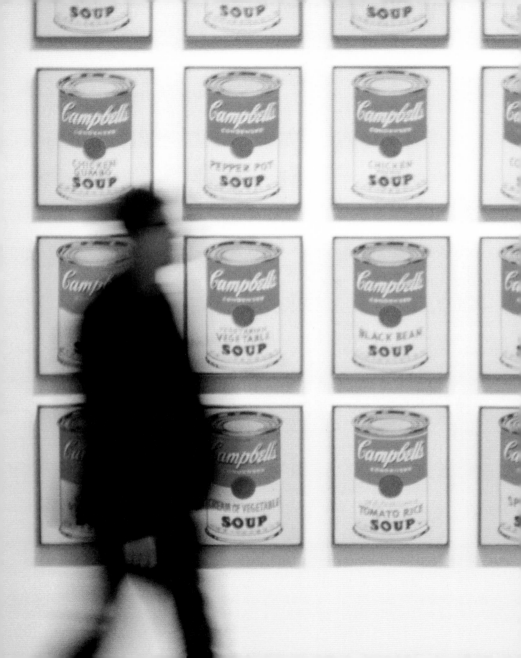

SLOW ME THE WAY

How long does it take to look at an artwork? Have you ever wondered about the answer to this question, while standing in front of one? Taking time is essential to appreciating art. Museums, however, offer surprisingly little guidance regarding how (long) to look. Once inside the gallery, you are on your own, as the museum assumes that the act of viewing art is self-explanatory. If you feel lost, it might offer you comfort that "Have I looked long enough at this piece?" is an often occurring thought in the mind of many an art museum visitor.

A symphony takes forty minutes, a film two hours, but museums let you decide how much time to spend with an artwork. This may be unfortunate. Artists spend weeks, months, even years creating a work of art. We spend a mere nine seconds on average looking at it. Even masterpieces cannot keep our attention for very much longer: we look at the Mona Lisa for just fifteen seconds on average.

Slow food aficionados honor the chef by spending as much time enjoying a meal as it took to prepare it. Museums could 'slow us the way' by posting suggested viewing times with certain artworks. It would at least make us more aware of how quick we look.

Slow viewing starts with the awareness that museums offer way too much to take in all at once. Do not do what others do, and exhaust yourself with viewing everything and therefore seeing nothing. Instead, choose and choose daringly. Devote time to truly getting to know a few artworks. Consider the museum a menu, not a checklist.

Art tends to reveal itself gradually as you spend time with it. That's why slowing down matters. Be aware, however, that plain staring does not allow you to see more. Getting acquainted requires effort, whether you ask yourself questions, consult the wall labels, read online articles on your smartphone, or invite fellow visitors to join in your contemplation of the piece. Artworks that speak for themselves do not exist. Find out which ways to explore and connect to art work best for you, and take your time in doing so. It will be worth it.

ART IS A CONVER-SATION

Art can make you hungry.
How hungry? →

THOSE WHO WANT TO GET THE MOST OUT OF THEIR VISIT SHOULD REFRAME WHAT THE RESTAURANT IS ABOUT.

Nothing whets your appetite more than, let's say, a still life of lobster and fruits so lush you can almost taste the fresh sea flavor of the pearly meat and the exotic sweetness of the sparkling macédoine of grapes, melon and peaches.

Giving in to your appetite is a crucial ingredient of a rewarding museum visit. But if you think the museum restaurant is only about having your coffee, cake or calamari, you're mistaken. Those who want to get the most out of their visit should reframe what the museum restaurant is essentially about. It's not the food, dummy!

The museum restaurant offers you the best, if not the only, opportunity to have a good talk about art. Because – and be honest now – how often does it happen that you actually have that inspiring, mind-bending exchange of thoughts that art is known to induce? Right: rarely. The galleries are either too silent or too crowded to accommodate it – and they tend to lack proper seating. It's the restaurant that allows you to settle in comfortably and take care of your inner self. This will offer you the opportunity to let your impressions sink in and muse casually on what you just saw.

Why not start off your visit in the restaurant? This may feel counterintuitive, but a worthwhile museum experience is very much a matter of tuning into the right mood and, beforehand, making up your mind about what it is you actually came for. The restaurant allows you to do this. Are you visiting a large art museum? Then return to the restaurant halfway through your visit, to avoid visual overload and to exchange the impressions you've had so far. "Did you see that?" or "Shall we have another look at …?" Eventually, when wrapping up your visit to the galleries, head to the restaurant one last time. Enjoy a glass of wine, while casually drawing your final conclusions together with your co-visitors.

That's right, why not consider visiting the restaurant two or three times during a single visit? Because really, what's the point of walking along hundreds of artworks in just several hours? We tend to take in too much art and spend too little time digesting it. "Art is a conversation," writer Rachel Hartman argues, and a good drink or a nice bite to eat helps us to welcome that interaction. So next time: see less, and talk more – at the restaurant.

WE TEND TO TAKE IN TOO MUCH ART AND SPEND TOO LITTLE TIME DIGESTING IT.

THE CUBA FOLDING FLOWER CHAIR

We turn into better observers when sitting down. You might thus expect museums to be full of chairs, sofas, or even divans. The opposite is true. Museums tend to consider furniture as superfluous. There are museums where you may find a mere two benches in the entire building. Or galleries where, somewhat sarcastically, the only chairs available are those intended for use by the guards.

Sitting was once an inherent part of the art experience. Nineteenth-century museums included seats in their exhibitions to slow your pace and to encourage you to observe closely and contemplate. This changed when curators became responsible for the gallery interior. Curators tend to be more passionate about serving the art, rather than you, the visitor. Most of them are not big fans of seats.

If museums want us to feel welcome, plentiful seating is a no-brainer. Decent chairs and sofas invite us to stay. They are, in fact, essential if the museum wants to serve as a vibrant public place where we can meet, read, talk, relax and practice people watching.

The reality is that the lack of seating ranks among museumgoers' top complaints. Nonetheless, few museums are taking action. Let's help them by making our wishes known and requesting some decent chairs around our favorite works of art. And why not ask for comfy sofas near the windows as well, including a current selection of art books and magazines for us to read as we unwind?

Can't wait that long? There's another solution, and it's called the Cuba Folding Flower Chair. Bring one with you and with a little persuasion – weren't you recovering from a hernia? – most museums will let you take it with you. It is then for you to decide to sit wherever you like.

Ultimately, when it comes to seats and art, there is one question that remains unanswered: where's that entrepreneurial museum director who will hire a designer to create a trendy and innovative folding chair, especially tailored to accommodating your museum visit? One that you can rent at the ticket desk and has an audio guide integrated. Guaranteed success!

YOUR LABELS MAKE ME FEEL STUPID

Museum labels are the small text signs you will find glued to the wall next to artworks. They usually feature Name of Artist, Name of Piece, Year of Execution, and Used Materials. Period. If a museum wants you to know more, it may include one or two sentences on the subject of the work or whatever else it deems necessary. But that's usually it.

You have likely found yourself standing in front of an artwork before, trying to connect with it, but not knowing where to start. In fact, this may have happened to you many times. This is why most of us are keen to rely on labels and often spend longer reading them than looking at the work itself.

Well-written labels can greatly enhance your museum experience. They allow you to create deeper connections to the art on display. "They answer the stupid questions in your head," according to museum expert Nina Simon, "and they tell contextualized stories that involve you. And they use layering: a simple, large-type label for people in a hurry, with a more detailed label below for those who want more information."

Museums tend to write labels in pompous prose, which may frustrate your need for vivid explanation or interpretation. In fact, research shows that "your labels make me feel stupid" is a dormant feeling that many museumgoers experience. At the same time, experts and art aficionados will likely tell you that art should speak for itself. They might want to make you believe that labels are subtitles for those who do not master the language of art.

Yet, most of us simply can't do without labels. We depend heavily on the curator, who decides on the tone, length and vocabulary of label texts. Whatever the quality of the prose may be, we will simply have to put up with it.

London's Tate Modern once let visitors write their own labels and stick them next to the artworks. It led to surprising and inspiring observations about the art, for everyone to read. If you really can't control your inner activist, you may consider bringing your own sticky notes and composing your own labels. Stick them next to the artworks and see what happens!

ANY QUES-TIONS?

When it comes to guided tours, there is one particular thing that makes or breaks your experience. →

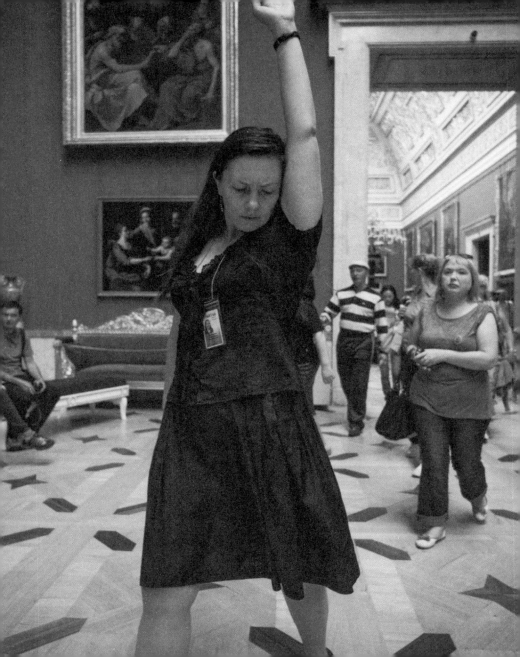

ART OPENS UP TO US WHEN WE ENGAGE WITH IT, AND WHEN WE TALK ABOUT IT.

It's not what you're touring that counts, but who is showing you around – the tour guide. If your tour guide is charismatic, passionate, smart, articulate, and knowledgeable – and, why settle for less? – he can make even the worst art exhibit interesting.

When it comes to art, it's particularly easy to just reel off a list of bland art history facts regarding which genre an artwork belongs to or what materials the artist used. But for many of us that does not bring art to life. What does do the trick is the tour guide's ability to turn facts into engaging stories and relevant wisdom. Which famous politician adored this drawing and why exactly? What does this video teach us about the struggles in our personal lives? Effective guides also invite thoughtful and challenging questions and comments from you. A popular tour at Tate Modern in London features tour guides that ask everyone for their impressions and opinions at each artwork. They then fine-tune their story based on the answers given.

If there's one place where guided tours can make a difference, it's at an art museum. Art opens up to us when we engage with it, when we talk about it, when we find out how others see it, and when we exchange our thoughts about the meaning of the work. That's why you should always take a shot at a guided tour, in the hopes of catching that one brilliant guide. Why not explicitly ask for him or her at the information desk? The excellent ones are always well known.

Being assigned a less talented guide doesn't mean things are out of your hands. You are part of the tour, which offers you the chance to turn a mediocre experience into a meaningful one. Here's how.

Contributing, as a visitor, to a guided tour is all about having the right mentality. Never be afraid of asking questions, especially the 'stupid' ones your co-visitors are afraid to ask. They will be grateful to you (whether they'll admit to it or not) and it might even encourage them to let loose.

The same goes for guiding your guide from feeding facts to delivering value. You can do so by asking him pragmatic, user-oriented questions. What can 'we as a group' learn from this installation? Why do I need to remember this particular artwork? Sharp, unexpected inquiry will add to your guide's alertness – and that of your co-visitors as well – and stimulate wit and creativity in the answers. Try to make things personal as well. Ask your tour guide about his own opinion, his favorites, his fetishes, and involve other group members. Soon enough, you'll find that a great tour guide never works alone. He is actually a team player and needs you and other bright visitors to fuel his excellence.

GUIDE YOUR GUIDE FROM FEEDING FACTS TO DELIVERING VALUE.

I feel wierd
~~and~~ art. Maybe I
my own.

A few ~~rare~~ ones we
like velvet Elvis. But

OPEN WELLS OF FEELING

The guest book is one of the most curious items in the museum. You will find it on a reading desk, strategically positioned near the museum exit. Lying face open with a pen in the fold of the creamy, white pages, it invites you to write down – well, what exactly?

In the age of Twitter and Facebook, the guest book could easily be regarded as an anachronism. Why write down what you can tweet or post? Nevertheless, the guest book still serves a strong need, especially in art museums. It allows visitors to express their thoughts on the brilliant, boring or mind-boggling art they just saw. And – this may truly explain the guest book's success – we finally get a chance to talk back to the museum!

Visiting an art museum can be quite an individual experience. We stand in front of artworks mostly by ourselves and in silence. No *oohs, aahs* or applause. Nevertheless, if you are eager to find out how your fellow visitors experience the museum, the guest book offers you a fascinating opportunity. It is a wonderful open space, where young and old, 'dummies' and experts, share their enjoyment, suggestions, jokes and criticisms regarding the museum and the art on display.

Museum guest books are a thrill to read. They are entertaining, inspiring and instructive. You will find strong public opinions on art and museums in three sentences or less. Or, as historian Bonnie Morris puts it after researching many guest books: "These books are open wells of feeling – some of the humblest, yet most dangerous outlets for anonymous writing in public places. Some signatures have the literary quality of a drunken phone call, while others contain eloquence worthy of the Nobel Peace Prize."

On your next visit, sign but also *read* the guest book. Make it your regular stop – a final, exciting reflection on what you just saw – before leaving the museum. You won't be disappointed.

PLEASE DISTURB THE ARTIST

Yoko Ono's exhibition "It's for you" show-cased a telephone. If you would happen to be near it when it rang, you had the chance to talk with Yoko live. All you had to do was pick up the receiver.

Talking to an artist sounds like a special opportunity, and it is indeed. Great artists can offer remarkable and inspiring insights into their art. Especially when put in their own words, their work may truly come to life. They can make you understand, and even feel, what it is like to create, thereby transferring a sense of immediacy in relation to the art.

A museum once allowed its visitors to watch an artist arranging his upcoming exhibition. It even placed a sign that read "Please disturb the artist." This opportunity, or call to action if you will, is equally exciting as it is rare. Generally, museums make little effort to let you get acquainted with an artist. Biographies, if offered at all, are often short and formal. Artist talks are rare, as are video interviews with artists, which a museum could choose to show. As a result, it often feels as if the artist is a mysterious entity, hovering over the art.

Museums like to keep the art separated from the artist, but don't let this fool you. Getting to know an artist is a basic form of human interest and offers an exciting peek behind the scenes. Getting familiar with his or her ideas, hesitations, presumptions, private philosophies and life story is essential to comprehending the work.

A personal exchange of thoughts with an artist may not be directly available to you. Nonetheless, there are other ways to gain a deeper understanding of what drives an artist. Prepare your museum visit by going online and, for instance, watching an interview with the artist whose work you're going to see. Or bring that artist's essay to read in the restaurant. And why not use your smartphone to search out additional information during your museum visit. Listening to recorded artist talks while looking at their work is like serving a fine glass of wine to a great dinner. You might find that it's actually a shame to do without.

A SKULL, APPLES AND A BOTTLE

A well-respected museum once defined still lifes as "anything that does not move or is dead." →

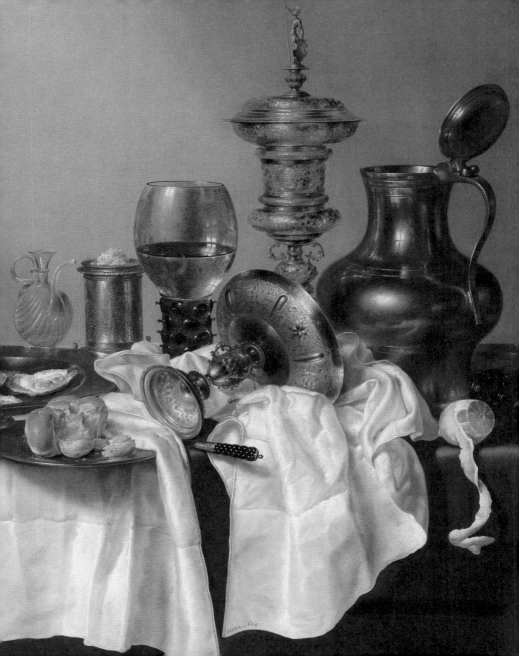

More accurately, a still life is a painting or photograph that depicts arranged, every-day objects. It may include anything from flowers, food or bottles to more explicit items, such as a skull or a dead pig. Once occupying the lowest ranks in the hierarchy of artistic genres, the still life managed to climb the ladder and remains relevant today. Finding an art museum without one will be quite the challenge.

"Landscapes come from fleeting glimps-es and memories; still lifes from the voluptuousness of form and pattern," painter Robert Genn states. However poetic this may sound, if you're not an artist or art expert and encounter still lifes in the museum, you will probably feel like you're staring at stuff. It doesn't help that museums consider the still life to be so established that they tend to let it speak for itself.

For those who are nevertheless eager to make sense of a skull, apples and a bottle – and could use some help in doing so – here's three clues that will encourage you to start appreciating this intriguing genre.

1

The one characteristic that binds all still lifes together is the fact that they all aim to creatively combine colors, shapes and textures into a sensual composition. If you delight in things such as a bright yellow lemon next to a shiny decanter with dark red wine, the pleasure can be ecstatic.

3

True still life artists are eager to make matter matter. They want to engage you, not with people or vistas, but with objects and their essence. "To copy objects is nothing; one must render the emotion they awaken in him," painter Henri Matisse argued. At its best, a still life lets you fall in love with a withered lily, fully sensing the transience of life.

2

Artists tend to select still life objects for their symbolic meaning. Cut flowers or decaying fruit symbolize life's impermanence. An exotic shell represents the vanity that comes with wealth. The use of symbolism can make the still life anything from an easy puzzle to a truly enigmatic riddle. If necessary, pull out your smartphone to find clues about what statement the artist wants to convey by the collection of objects on display. And if you consider a skull or a candle a no-brainer, then try to find some contemporary still life photography – this is sure to challenge you with some less predictable symbolism.

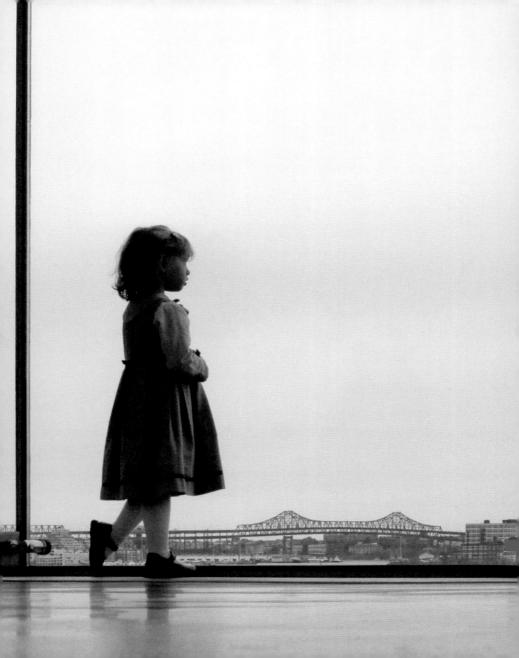

BRINGING THE OUTSIDE IN

Art purists find windows in the galleries distracting. Many museums therefore seal off their gallery windows. White cube etiquette requires the outside world to stay outside. As a result, you might never have experienced the interesting fact that looking out of a museum window can actually enhance your visit.

"I always like looking out of windows in museums," writer Gertrude Stein once said, "it is more complete than looking out of windows anywhere else." Painter Pierre Bonnard even claimed, after visiting the Paris Louvre, that "the best things in museums are the windows." Indeed, there's something special about looking at the world from a gallery window. But what exactly?

Art demands focus and attention. In the presence of great art – and, inevitably, terrible art as well – it can be a relief to look away now and again. A well-positioned window offers you that opportunity. Use it to 'unfocus', for instance by watching something ordinary and amusing – someone having trouble parking their car – and you'll soon be ready for more art.

White cube galleries look the same all over the world. It's the windows, then, that will remind you of where you are by bringing the outdoors inside. Whether it's the urban hustle and bustle that makes the museum feel comfortable and serene, or the weather that adds *couleur locale* to the art on display (nothing better than a cold, cloudy day when absorbing gloomy Anselm Kiefer paintings), thoughtfully taking in your surroundings will intensify your art experience.

Is there more to museum windows? There is, according to artist Harrell Fletcher: "In museums the views out of windows are accentuated because of the headspace you are put into by the nature of the museum. When you look outside, you can see things anew, because of that framework established in your mind. It's about the art you just saw and how you apply it to your life in the world, your understanding of big and little things out there."

Soothing your senses, watching life go by, or having a metaphysical experience – there's always something to gain from looking out of a museum window. Next time, treat the window like you would treat any painting.

WHAT BRINGS YOU HERE?

Knowledge, interests, prior experience, preconceived ideas – you arrive at the museum anything but empty-handed. →

All of this profoundly influences what you do, think and feel when touring the museum. It makes museum visits deeply personal, according to researcher John Falk. After interviewing hundreds of people, Falk identified five museum identities. Each one represents a different personal goal motivating your visit.

FACILITATOR

If someone you care for prompted your visit, you're likely to be a facilitator. Whether it's your partner, friend or visiting relative, you want them to have a meaningful social experience. Be sure to hang out with them, chat, visit the restaurant and, occasionally, glance at the exhibit.

EXPERIENCE SEEKER

Do you go for the iconic pieces and look for the must-sees? Welcome, experience seeker, you're probably checking off your bucket list ("been there, done that"). Make sure to take your pictures and enjoy the thrill.

RECHARGER

If you're a recharger, you're here to recuperate – physically, intellectually or emotionally. For you the museum is a place to rejuvenate and 'get away from it all'. Your visit may even qualify as spiritual. It's best to come when it's quiet so you can intensely enjoy the sense of the place, the atmosphere and the reclusiveness.

EXPLORER

If you didn't come to see a particular exhibition, but want to satisfy your intellectual curiosity more generally, you're likely to be an explorer. You're an opinionated individual, used to finding your own way. Avoid crowded exhibitions or guided tours, as they are too restrictive for you. But do read the labels; they'll fuel your learning.

PROFESSIONAL

Artists, educators, curators and other art experts; Falk considers you professionals. You're unlikely to read this book, but if you do, further instructions on how to visit an art museum are uncalled for. You're very comfortable finding your way around the museum.

It's likely that you haven't given much thought at all to your exact motivation for visiting. Taking a moment to ponder your unuttered reasons may give you some interesting insights. Falk's 'motivating identities' offer powerful clues as to what museum strategy works best for you. According to him, one of these profiles suits you. So take your pick, get to know yourself a little better, and act accordingly. Consider it your personal success recipe for having a rewarding visit.

ALSO AVAILABLE AS A POSTCARD

There is an art museum where some of the artworks come with the remarkable sign "Also available as a postcard." It makes you wonder. Is this some kind of seal of approval? Does the museum want to reassure you there's no need for a dramatic goodbye, as you can take a miniature of your favorite painting home with you? Or is it just a friendly reminder to visit the museum store when you're done?

The museum store is usually the last stop before you leave the museum. After the galleries got you high on art, the store beams you back to reality. From Andy Warhol finger puppets to inflatable versions of Edvard Munch's *Scream*, the mass produced *kitsch* that art museums sell can be overwhelming. But don't entirely (dis)regard museum retail as mindless fun or a necessary evil. A decent store can play an essential role in making your museum visit worthwhile. Here's how.

A well-equipped store offers you the kind of abundance that is often withheld from you while inside the galleries: strong analysis and captivating stories about the artists and their work. This is why you should turn things around and start off your visit in the store. Whether it's a well-written exhibition catalogue or an insightful artist biography, choose something that's relevant to what you're going to see. Find a good spot – hopefully even a chair – and prepare for your visit by reading a little. It will make your time in the gallery more worthwhile. Even better, buy your book and bring it to the gallery. There's no greater place to read about art than right in front of it.

There's another reason to take the store seriously. The memory of your museum visit needs time to take definite shape. Research suggests that if you rethink your visit sufficiently afterwards, you are more likely to remember it as worthwhile. A strategically placed postcard of your favorite painting pinned to the bathroom mirror may offer you just the right avenue to do this. Kitsch or not, souvenirs thus serve as important messengers of meaning. They extend your art experience, allowing you to digest it and, finally, remember it fondly. Consider souvenirs your future memories.

PAIRING PARKER

WITH POLLOCK

Ever experienced the impact of minimalist Morton Feldman's music on your perception of Rothko's color fields? →

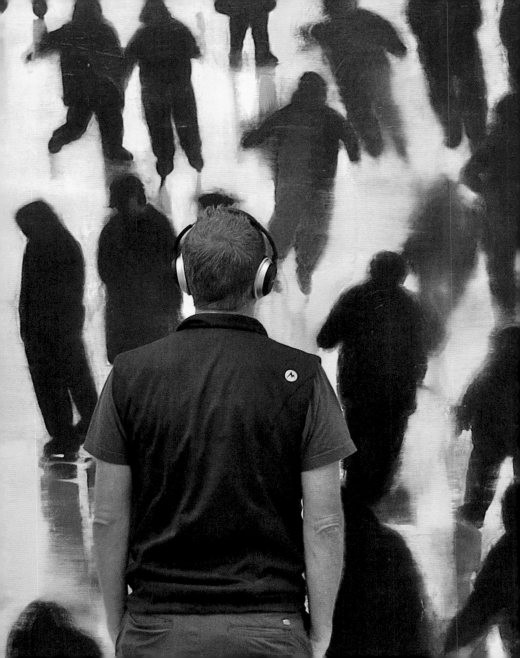

Or did you know that listening to Charlie Parker helps you to find visual pathways in the drip paintings of Jackson Pollock? No? If you have never coupled music with art before, there's a whole new world out there waiting for you.

In line with white cube etiquette, silence is considered to be golden inside art museums. That's why many of them feel like art temples. That's fine, of course, if that's what you're after. However, for many of us, being inside a completely silent, large space makes us feel uncomfortable. When you can hear the guard's every breath, and people start to whisper, you get a sense that there might be such a thing as too much stillness. It is an established fact that our brains are able to connect music to color and form. So why not put on some music? There's no particular reason for museums to adhere to the principle of silence so radically. Don't be afraid, we're not trying to turn the museum into a disco. When treated respectfully, sound creates an appropriate atmosphere that makes people feel relaxed and make them more likely to override their 'shussh!' expectations and talk.

Music or even ambient sounds can encourage us to look at art differently. It can articulate or enhance the emotional, thematic or dramatic aspects of art, especially if the music drives a deeper understanding of the works on view. A soundscape of a glacier calving, for instance – low in volume, almost subliminal – can be the spark that illuminates your experience of Nordic art.

THERE MIGHT BE SUCH A THING AS TOO MUCH STILLNESS INSIDE ART MUSEUMS.

MUSIC CAN ARTICULATE OR ENHANCE THE EMOTIONAL, THEMATIC OR DRAMATIC ASPECTS OF ART.

Can't wait for museums to press play? Here's what you can do yourself. Take your mp3-player or smartphone. Start by selecting music that gets you into a specific mood that matches the museum that you will be visiting. Be your own DJ: you know what works for you. Bring the music to the museum – use your earphones! – and explore how it influences your art experience. Find out what tracks work and which ones don't. Congratulations, you have now embarked on your personal learning curve.

When preparing for your next visit, think more specifically about the art you'll encounter. Create your own playlist by choosing mini-soundtracks for specific works. Soon, you might be challenging yourself by choosing surprising pairings – music that makes you consider the art works from unexpected angles. Or you might find that you're starting to think of sound and image as entities. But beware. Before you know it, you'll be hooked, and standing in front of a piece of art without any musical accompaniment will feel like looking at a silent movie.

AN ART MUSEUM CAN BE A GREAT PLACE TO MEET A FRIEND AND HAVE A MEANINGFUL CONVERSATION ABOUT LIFE, INDUCED BY WHAT'S ON DISPLAY.

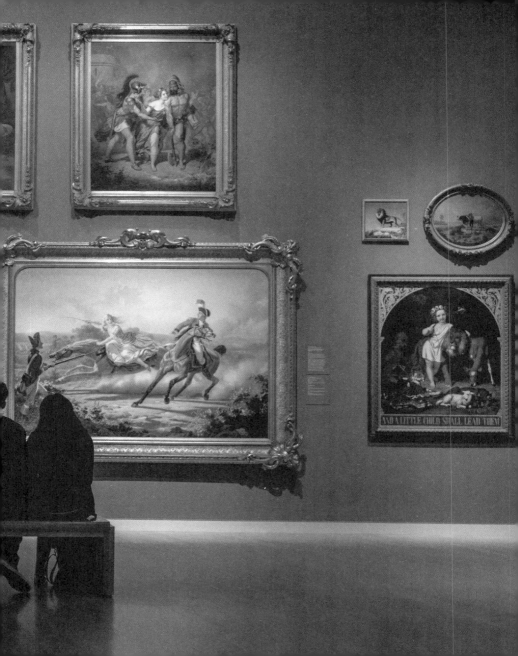

PAST THE INITIAL SHOCK, YOU WILL OFTEN FIND A WORTHWHILE THOUGHT OR MESSAGE — ONE THAT MAY NEED SOME CONTROVERSY TO BE TOLD EFFECTIVELY.

ARTISTS CAME UP WITH
THE ART, NOW YOU GET
CREATIVE WITH TAKING
ITS PICTURE.

DEVOTE TIME TO TRULY GETTING
TO KNOW A FEW ARTWORKS.
CONSIDER THE MUSEUM A MENU,
NOT A CHECKLIST.

MUSEUMS THAT MAKE YOUR VISIT WORTHWHILE

This book places the challenge of having a rewarding museum visit in your own hands. But, of course, your satisfaction is just as much a responsibility of the museum itself. Here's a ridiculously random selection of museums that do offer you the kind of opportunities this book suggests.

Where can I encounter a gallery guide?
See → Ask me about the art
The Guggenheim Museum in New York City stations gallery guides throughout the museum. They offer you the extraordinary opportunity to explore art through one-on-one conversation.

In which museum can I get my hands-on experience?
See → He felt smooth and firm
The Louvre Museum in Paris has a Touch Gallery originally targeted to the blind and partially sighted. It has, however, rapidly become a great way for museumgoers in general to have an altogether new (and blindfolded!) experience by engaging with the sculptures on display.

Which museum allows me to pair a coffee with an artwork?
See → Art is a conversation
Museum de Fundatie in Zwolle (the Netherlands) boasts a coffee bar inside the top floor gallery that provides ample caffeine for visitors who have trouble keeping their museum legs going.

Which museum allows me to experience the brilliance of a kid art guide?
See → The perfect antidotes
MoMA Unadulterated, an audio tour created by kids, can be enjoyed at the Museum of Modern Art in New York City. Artworks are analyzed by experts aged to 10, as they share their unique, unfiltered perspective on, among others, composition, art's deeper meaning, and why some artworks are so weird looking. This is an unofficial tour, created without the express permission of the museum, and which you can download online.

WHERE TO GO?

Which charismatic, passionate, smart and articulate tour guides should I not miss?
See → Any questions?
Museum Hack is a highly interactive, subversive, non-traditional museum tour at the Metropolitan Museum of Art in New York City. This band of renegade tour guides leads you through the museum on an adventure characterized by passionate storytelling and juicy gossip. The tours highlight the personality of the museum in an attempt to turn even the most skeptical visitor into a fan.

Where can I learn how to recognize bad art?
See → The beauty and the bullshit
The Museum Of Bad Art (MOBA) in Boston is the world's only museum dedicated to the collection, preservation, exhibition and celebration of bad art in all its forms. As the museum aims to bring the worst of art to the widest of audiences, here's your best chance to find out and learn what bad art is all about.

Where can I sit comfortably in the gallery?
See → The Cuba Folding Flower Chair
The Fondation Beyeler near Basel (Switzerland) has a beautiful gallery dedicated to Monet's *The Water-Lily Pond*. Here you can lounge on a comfortable sofa. In fact, it feels as if you've been invited over for a private viewing. Monet's masterwork and the real water lily pond right outside the floor-to-ceiling glass window, make for a perfect match.

Which museum guard may surprise me most?
See → The eyes of the museum
If you happen to visit the Walker Art Center in Minneapolis and notice a guard suddenly balancing on one foot or striking a yoga pose, it's most likely Todd Balthazor. "I'm stretching all the time," he says. "You have to do that, or else you are going to stiffen up." To stay focused, he has developed his own style, such as memorizing visitors' outfits. Todd has many great stories to tell. Additionally, he keeps an eye out for material for his autobiographical comic strip, which you can have a look at on the museum's website.

What's a good museum window to look out of?
See → Bringing the outside in
The Institute of Contemporary Art (ICA) in Boston has a floor-to-ceiling glass window, which spans the entire width of the north end of the museum. As it's a separate space that connects the east and west galleries, it provides you with the perfect opportunity to sit down on one of the sofas, enjoy the magnificent view over the harbor, and let the exhibition soak in.

READ MORE

Art as Therapy (2013)
John Armstrong
and Alain de Botton
(Phaidon Press)
"Upending the art world's self-referential culture, this book proposes a profoundly refreshing and heterodox approach to art as a 'therapeutic medium' that can help people access 'better versions of themselves.'"
—Publishers Weekly

But Is It Art?: An Introduction to Art Theory (2002)
Cynthia Freeland
(Oxford University Press)
"A survey of everything from aesthetic theory to digital imaging, and of everyone from Goya to Damien Hirst, is packed into seven fast-break chapters. Freeland is familiar enough with the impenetrable artspeak not to be intimidated by it."
—Publishers Weekly

Identity and the Museum Visitor Experience (2009)
John Falk
(Lef Coast Press)
"John Falk's determined focus on the visitor's experience continues to transform our understanding of the relationship between museums and their audiences."
—Nannette Maciejunes

Ignite the Power of Art: Advancing Visitor Engagement in Museums (2011)
Bonnie Pitman
(Dallas Museum of Art Publications)
"Ignite the Power of Art sparks visitor connectivity with museums. This work is an inspiring contribution to all museums that seek memorable and meaningful visitor engagement."
—Shelley Kruger Weisberg

Museum Legs: Fatigue and Hope in the Face of Art (2009)
Amy Whitaker
(Hol Art Books)
"Whitaker's sparkling meditations on the museum are both delightful and pressing. She explains how we might retain our sense of wonder, and how museums might rediscover their essence: relating to patrons without being patronizing."
—Jonathan Zittrain

Seeing Out Loud (2003)
Jerry Saltz
(The Figures)
"Jerry Saltz looks at art from the perspective of the viewer, the ignorant, the lover, and the enemy. His writing is overwhelmingly passionate, yet without sentimentality."
—Francesco Bonami

The Participatory Museum (2010)
Nina Simon (Museum 2.0)
"The Participatory Museum has the resonance of a manifesto and the potential to make a transformative impact on museum practice and visitors' experiences in museums in the coming decades."
—Eric Siegel

We Go to the Gallery (2013)
Miriam Elia
(self-published)
"Have you taken children to a gallery recently? Did you struggle to explain the work to them in plain and simple English? Well, those awkward moments are now over. Miriam Elia has created a colourful new 'Harlequin Ladybird book', for parents and young children to understand contemporary art (but mainly parents)."
—Miriam Elia

ACKNOWLEDGEMENTS

Man looking at black painting
Frenci ⓒ
www.flickr.com/photos/
36804213@N02/6872445466/
in/pool-museu/

Woman in gallery
Nickolai Kashirin ⓒ
www.flickr.com/photos/
nkashirin/6995428632

People photographing Mona Lisa
Giorgio Galeotti
www.flickr.com/photos/
fotodispalle/6187011138

Couple sleeping on bench
Anna Kucherova

Woman looking at Rothko
Jeff Suhanick

Man looking at painting
Marius Vieth
www.neoprime.de

1. The eyes of the museum
 Library of Congress

2. Walk slowly, but keep walking
 Kevin Dooley ⓒ
 www.flickr.com/photos/
 pagedooley/10734758835

3. Paintings without people in it
 Ryan Baumann

4. When art occurs
 Alex Ford ⓒ
 www.flickr.com/photos/
 alex_ford/3197685033

5. The beauty and the bullshit
 Arie Odinocki

6. Where art ends and the
 world begins
 Christopher Mejia

7. Shock Me if You Can
 Damien Derouene

8. But, is it art?
 Damien Derouene

9. Friends you haven't yet met
 Tim Schreier

10. Chewing gum sticking on the
 inside of your brain
 René den Engelsman

11. The perfect antidotes
 Huub Louppen

12. Reality functions as my field
 of action
 Ngader ⓒ
 www.flickr.com/photos/
 ngader/283114579

13. The soul of a museum
 Larry Closs

14. The undisguised view of
 the human body
 Kristin Van den Ede
 www.flickr.com/photos/
 kristinvandeneede

15. He felt smooth and firm
 Damien Derouene

16. Untitled #3, 1973
 Johan Idema

17. No photos!
 Bill Holmes

18. Not just a graveyard for art
 Nathan Williams ⓒ
 www.flickr.com/photos/simi-
 ant/277297562/in/photostream/

19. Selfies avant la lettre
 Kevin Dooley ⓒ
 www.flickr.com/photos/
 pagedooley/4595276262

20. Ask me about the art
 Damien Derouene

21. Slow me the way
 Sorkin ⓒ
 www.flickr.com/photos/
 sorkin/3333319378/in/
 set-72157617341120574

22. Art is a conversation
 Sharon Mollerus ⓒ
 www.flickr.com/photos/
 clairity/3571805791

23. The Cuba Folding Flower Chair
 Brian Jeffery Beggerly ⓒ
 www.flickr.com/photos/
 beggs/34117210

24. Your labels make me feel stupid
 THX0477 ⓒ
 www.flickr.com/photos/
 59195512@N00/4329128880/

25. Any questions?
 Witold Riedel

26. Open wells of feeling
 Rachel Leah Blumenthal

27. Please disturb the artist
 See-ming Lee ⓒ
 www.flickr.com/photos/
 seeminglee/3988318885

28. A skull, apples and a bottle
 Rijksmuseum

29. Bringing the outside in
 Tjook ⓒ
 www.flickr.com/photos/
 tjook/5176521048

30. What brings you here?
 Andrew Brannan ⓒ
 www.flickr.com/photos/
 andybrannan/3593456861/

31. Also available as postcard
 Skagens Museum ⓒ
 www.flickr.com/photos/
 skagensmuseum/9932651325

32. Pairing Parker with Pollock
 Torbakhopper ⓒ
 www.flickr.com/photos/
 gazeronly/10412144466

Couple looking at paintings
Robert Couse-Baker ⓒ
www.flickr.com/photos/
29233640@N07/12859956864

Birds eating
Amy Huggett

Couple looking at installation
Itinerrance

Woman looking at sculpture
Paul Stevenson ⓒ
www.flickr.com/photos/
pss/5274132701/in/pool-museu/

Man looking at Monet
Andres Fernandez

ABOUT THE AUTHOR

Johan Idema is a passionate promoter of innovation in the art world. He works as a consultant, writer, and cultural entrepreneur. He specializes in creative concept development, business planning, innovation management, and fundraising.

Johan has worked at several cultural institutions and has extensive experience as an art consultant. He is a regular public speaker and has a track record in writing. His recent publications include *Beyond the Black Box* and the *White Cube* (2009) in which he introduces new ways of thinking about museum and theater architecture and *Present! – Rethinking Live Classical Music* (2011) that focuses on how to make live classical music more exciting and accessible.

Johan is a frequent visitor of art museums around the world.

www.johanidema.net

INDEX

INDEX